SELL
ONLINE
Like a Creative Genius™

SELL ONLINE

Like a Creative Genius™

A GUIDE FOR ARTISTS, ENTREPRENEURS, INVENTORS, AND KINDRED SPIRITS

BRAINARD CAREY

ALLWORTH PRESS
NEW YORK

Allworth Press books may be purchased in bulk at special discounts for sales promotion, corporate gifts, fund-raising, or educational purposes. Special editions can also be created to specifications. For details, contact the Special Sales Department, Allworth Press, 307 West 36th Street, 11th Floor, New York, NY 10018 or info@skyhorsepublishing.com.

23 22 21 20 5 4 3

Published by Allworth Press, an imprint of Skyhorse Publishing, Inc., 307 West 36th Street, 11th Floor, New York, NY 10018. Allworth Press® is a registered trademark of Skyhorse Publishing, Inc.®, a Delaware corporation.

www.allworth.com

Cover design by Mary Ann Smith

Illustrations by Shiva Carey

Library of Congress Cataloging-in-Publication Data
Names: Carey, Brainard, author.
Title: Sell online like a creative genius: a guide for artists,
 entrepreneurs, inventors, and kindred spirits / Brainard Carey.
Description: New York, New York: Allworth Press, an imprint of Skyhorse
 Publishing, Inc., [2019] | Includes index.
Identifiers: LCCN 2018034748 (print) | LCCN 2018036185 (ebook) | ISBN
 9781621536512 (eBook) | ISBN 9781621536499 (pbk.: alk. paper)
Subjects: LCSH: Electronic commerce.
Classification: LCC HF5548.32 (ebook) | LCC HF5548.32 .C3597 2019 (print) |
 DDC 658.8/72—dc23
LC record available at https://lccn.loc.gov/2018034748

Paperback ISBN: 978-1-62153-649-9
eBook ISBN: 978-1-62153-651-2

Printed in the United States of America

This book is dedicated to you—the dreamer who wants to live life to the fullest and have an income stream that allows your dream to come true so you can embrace the best things in life, like the people you love.

♥

CONTENTS

INTRODUCTION

Selling anything online takes three things: a plan, determination, and ambition. And one more thing that will undermine the first three things if you overlook it—your issues with "selling" or "promoting" your vision, whatever they are.

In this book, you will learn how to manage your vision and keep going despite potential setbacks because failure itself is an experience that must be confronted; it will surely recur many times as you embark on an independent venture to develop an income stream of your own.

You will also learn what every entrepreneur knows—how to make a "funnel" that will automate sales and customers. It is truly the way everything sells on the internet, and while I will give some examples of other one-off methods, for those who want consistent sales, a funnel is something you must understand, build, and master.

Rest assured, there is a method here for you. If the "funnel" I describe seems too ambitious for you, there are other ways to generate sales that are simpler, though those methods often require more attention as they cannot be fully automated. Let me explain in detail!

"Art is making something out of nothing and selling it."
—Frank Zappa

Chapter 1

CHANGE THE WORLD

Who is your audience? How will you reach them? How will they buy what you're selling?

Change the world. Let your ambition lead you through this book.

If you want to sell something online—from art you make to a small business with products you are launching or a service you provide—there are three main things to think about.

One: who is your audience, and who might buy what you have to sell?

Two: how will you reach them?

Three: how do they actually buy and receive what you are selling—from credit-card processing to shipping?

Those questions may seem elementary, but actually they are part of what we will get into in the next chapter on funnels. Your audience is often more of a specific niche than you think. For example, if you are selling candles, you might think everyone needs candles, so your audience is everyone. But actually, age range, among other factors, will narrow it down. Children and teens probably don't want candles, and the technologically obsessed may not want your candles. Survivalists will want them for sure, and so will other people, depending on what's in the candles. If they are made of organic beeswax with no additives, for example, there is a specific audience that is concerned about indoor air quality and will be interested in a product that is less harmful to inhale.

If you're selling art, it may also seem like everyone can buy art, but there is an age demographic there, too. Perhaps there is an educational demographic as well because buying art is a bit sophisticated on one level—to understand why something is beautiful and of value as an artwork is not an easy evaluation to make as a buyer. It often takes an education to understand art and to make a decision about buying it. You have to have a form of "visual literacy." All of these are parameters you need to take into account when deciding who your audience really is.

For the second element concerning how you will reach your audience, there is what is known as "targeting" an audience. Your audience may live in a certain part of the world or in cities or away from major cities, or they may be doing certain online activities.

In the examples I have discussed so far, I used survivalists and art collectors. Survivalists may not be living near a city center, may have specific political affiliations, and would most likely be interested in going to specific websites or attending events and camps designed to support their interests. Art collectors also have habits that are similar in terms of what they might do and see and where they live.

The third element of this book is about the funnel I will describe—which is probably of greatest interest to you, or at least that is the part where success is measured. How do they actually buy from you online and through what process? Are they using their credit card or PayPal, and how easy or difficult is it for them to go through the steps it takes to purchase your product? The final part of this is the cost of shipping and handling. That may seem like the easy part, but that is where many small businesses get bogged down in spending too much time on the processing of orders, which can cut deeply into profits.

Before we jump into the architecture of a sales funnel, let me outline a few basic methods that many people use to start making sales without a funnel.

The well-known site eBay is a platform with built-in buyers. You can sell your new invention or product or your art there. The process is fairly straightforward. On eBay, you can post images, make a video to help discuss your work, and of course, you have a few options in terms of selling. You can have a "Buy-It-Now" price, and you can also create an auction. The auction is an exciting format no matter what you are selling because people feel like they might get a really good deal— and they might! You can always have a reserve price, but if you sell some of your products or your art at a reduced rate, it gets people interested. And when several people don't get the item in an auction, it generates a desire to want it in the future.

Amazon is also another very popular platform for selling your products and testing the market as well as selling art. Both of these methods require promotion to keep sales going, as well as reviews, but you can help that along by being very active on those sites.

For eBay, that means posting something every day. I do mean *every day.* You will build up an inventory this way, especially if you are an artist, and if something doesn't sell for the reserve price or higher, just keep relisting it.

On Amazon, you can keep adding more versions of your product, or you can keep adding more content by adding to the description and testimonials from previous buyers.

I will talk more about making sales this way in Chapter 9 "Selling without a Funnel."

There are dozens more sites like these two where you can get your feet wet in online selling, but if you want consistent sales, you will need a campaign and a funnel, and this is where Chapter 2 picks up.

CHAPTER 1
TAKEAWAYS

1. Who is your audience?

2. How will you reach your audience?

3. How will they pay you?

4. How will they receive your product or service?

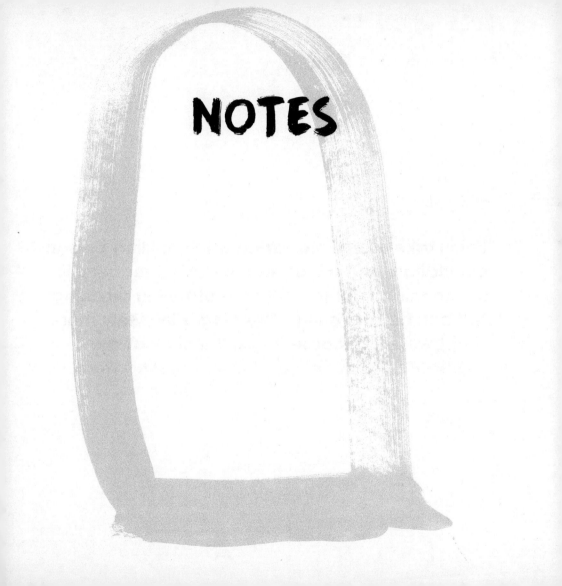

NOTES

"If you take a print magazine with a million-person circulation, and a blog with a devout readership of one million, for the purpose of selling anything that can be sold online, the blog is infinitely more powerful, because it's only a click away."
—Tim Ferriss, author of *The 4-Hour Workweek*

Chapter 2

THE FUNNEL EXPLAINED

When we talk about online selling, what we mean is that people will find your product on the web, and they will buy it. They will see it while browsing on their phone, tablet, laptop, or home computer. Since many users are looking at Facebook or Twitter or another social platform, that may be the first place they learn about your product or service, and that is where they may make the decision to find out more and possibly buy from you. The process by which an ad on the web leads to a sale is called a "funnel" because it funnels people down a particular path that leads them to a place where they can purchase something.

Most funnels work like this: Place ads on Facebook or Instagram. The ad gives away something, or people sign up for a mailing list to learn more or get a discount, or there is a free webinar. Now you have the potential customers' emails and can send them repeated offers until they buy. The End.

That is the basic architecture of a funnel, but let's break that down a little further.

The first step is the initial ad or ads you are placing. There are some alternatives to ads of course, like neighborhood posters or writing an article that gets national attention, but ads are still the best way to ensure consistency. If you have an ad campaign that works, you can keep it going and reach a national or international audience. I will use Facebook as my primary example because, right now, it is still the dominant platform for advertising, with Google coming in second. The reason for this is because we all tend to give Facebook a tremendous amount of our personal information. I am not talking about the quiz apps that illegally took information from users in 2018; I am talking about the information that we all willingly put on there. Information like where we live, where we grew up, our gender, our education level, our relationship status, our interests, and more.

We all tend to give Facebook
a tremendous amount of our
personal information. . . . Because
of that, it is an extraordinary
place for advertisers.

FACEBOOK AND YOUR INFORMATION

Because we give all that information to Facebook, more than any other platform, it is an extraordinary place for advertisers. Before the year 2000, if you wanted to place an ad for anything that would reach your intended audience, you would take an ad in a print publication or radio or television and hope that your intended audience was reached. However, it was always a guess because a magazine or other media would reach a wide readership, and only a fraction of that readership would respond or even be your intended audience.

Now with advertising on places like Facebook, you can not only reach a specific audience, you can also tell when potential customers just watched your video or "liked" your ad but took no other action. Now compare that to the previous advertising models before the year 2000, and you'll see how much more feedback you can obtain and how that information will help you. You can probably already see where this is going. For the first time in history, we can choose very specific details about the demographic we want to reach, which is a big boon for advertisers!

The first part of your funnel is to make ads that work. That means people "like" the ads, share them, and comment on them, and there is a minimum of negative comments.

CHAPTER 2
TAKEAWAYS

1. Do you know what an online funnel is?

2. What would your funnel sell?

3. What would the audience see in an ad?

NOTES

"Selling is helping people do what they're already inclined to do."
—Daniel Pink, author of *To Sell Is Human*

Chapter 3

MAKING YOUR FUNNEL AND TESTING IT

The next step is how to place ads on Facebook and other platforms. I will also briefly discuss scams and frauds from other people selling courses on this type of marketing—the process of making a funnel.

If you have previously heard about a "funnel" in terms of internet marketing, you may have heard it from online ads, ironically. For anyone trying to sell something online, a funnel is needed to generate traffic. Customers are guided by a "funnel" through a series of events until they are on your sales page, making a decision. If you are already on this path to selling something online, you may already be seeing ads for how to "sell more." That means you are being tracked and pursued by advertisers wanting to teach you how to make a funnel to generate sales. What any of them will teach you in the courses they sell—which can run up to thousands of dollars—is what I will explain in this chapter and the following chapters. I will also give you ways to get even more support for your process of selling, so keep reading closely.

As I said in the last chapter, a funnel is essentially this: Place ads on Facebook or Instagram or YouTube. The ad gives away something, or people sign up to a list to learn more, or there is a free webinar. Now you have the potential customers' emails and can send them repeated offers until they buy.

ADVERTISING

Let's begin with the advertising part. You will see offers from online marketers claiming they will teach you how to make a funnel without spending a dime. What that deceptive phrase actually means is that they will explain how to advertise online and get a good ROI (return on investment) so that, in the end, you make a profit as opposed to losing money. You do actually have to spend money with advertising, but if you do it correctly, you will make a profit. Thus the deceptive phrase "without spending a dime" would be more accurate if it were "how to advertise and make a profit." But that doesn't sound as catchy, right? I mention this because everything you need to know will be explained in this inexpensive little book. Even if you decide to have someone build the whole funnel for you, there is no need to spend thousands on that. You can hire people for much less to do this work once you understand the architecture of it all, and I will also explain how to hire people in a later chapter of this book.

Let's start with your product or service. Perhaps it's art, or maybe it's a small invention or a large one, or a coaching service, or a book. Your ad is what you need to design next.

My business is teaching classes online, so my ads are of two types on Facebook. I have one ad that simply says, "Join my free newsletter subscription to get more resources for artists, like grant lists and other opportunities." In this case, I am using something called a "lead" ad on Facebook, which means when a customer clicks on the link to "subscribe" to my newsletter, their email and name are already filled in, and they just move on to the next step which confirms their subscription. It is very simple and is one way to build your mailing list. The cost of getting people to sign up in my lead ads is about one dollar per email obtained. This is fairly inexpensive for a lead, meaning the person who is signing up has a fairly high likelihood of being interested in your product and buying it in the future. The other type is called a "display ad"; this is usually an image with text or perhaps a video. Its main purpose is to pique the interest of potential customers and to provide a clickable link that will bring them to your website; it doesn't capture their email on the spot. In this chapter, I'll get into the details on both kinds of ads and how you can use them.

LEAD ADS AND YOUR PRODUCT

Let's say you are selling a different kind of product, like a health-care product or even your own art. An example of your lead ad for a health-care product might be to ask people to sign up on your list for "free health-care tips" relating to your product, like tips to stay fit or tips to care for your skin. If you are an artist, your audience is collectors, not other artists, so your lead ad might be something like, "Interested in collecting art? Join my free email list, and I will show you how to collect art and build a collection that is valuable and beautiful." Then they click the link to subscribe, and they are on your mailing list.

CREATIVE LEAD ADS

You can also offer a free download of a set of instructions. For health-related products, it could be "How to Care for Your Skin" or "How to Keep Fit with 10 Minutes of Exercise a Day." When they are on your mailing list, they'll get a download of a PDF that could be as little as two or three pages with illustrations to get them interested in what you are selling. For artists, it could be a PDF download of "How to Collect Art and Build a Collection." Other products or services could have similar downloads. For example, if you are selling real estate, it could be a PDF download of a set of tips, such as "The 10 Mistakes First-Time Homeowners Make." You can be very creative here, of course, and you will know if it is working because you are either getting a lot of email sign-ups or not many at all.

You do actually have to
spend money with advertising,
but if you do it correctly,
you will make a profit.

THE COST OF LEAD ADS

Consider the cost of obtaining emails, too. Do you have a low rate (under $1 each) or is it costing too much ($3 or more)? Some businesses may feel comfortable paying more for customers' emails because their product cost is higher. For example, if you are selling luxury watches that start at $2,000, you just need one sale to justify spending $5 per name for the first 300 names. Using that as an example, if you spend $5 per email through a Facebook lead ad, and you make a $2,000 sale after spending $1,500 on 300 emails, you might be breaking even in terms of making a profit. Bur remember, you also have 299 other names on that email list, and if one of them buys, you are in the green. You are way ahead now because you already paid for the ad with that one sale.

The lead ad from Facebook is just one type of ad, and it is fairly simple, but you can also hire people to help you with these things. I will talk about that in a later chapter.

DISPLAY ADS

The other type of ad that I run regularly on Facebook is the "display ad." This is the kind you see more often, with more text, often a video or image, and a link to be sent directly to a website or perhaps download a book. It is not designed to capture an email immediately and have the process end there like a lead ad. Instead, it is designed to get a potential customer to your website or perhaps a webinar. I use these types of ads even more than lead ads on Facebook.

WEBINARS

The display ad attracts my potential customers, who are students for my courses, to a free online webinar. In that online webinar, I give a live talk about the information they are interested in. The talk I give is full of information they can actually use—not just partial information, but real usable information they can run with. Then I offer them a class at the end, in case they want personal attention and more support.

That is the format for most webinars these days: give real and useful information, answer questions from the audience during the webinar, and offer them more support. If you are selling a product, you can offer them the product at the end.

In the case of a health-care product, your webinar could be on ways of maintaining healthy skin, general fitness, or similar topics. Then you can offer your product as a support or shortcut to get some of the results you are talking about.

It is important in this age, when we have web access to everything, to give people useable information and not just a tease because everyone knows you can Google how to do anything. Offering personal support or a product at a discount is the way to go, and being sincere about it and transparent goes a long way because you can assume your potential customers are educated in terms of how to find information on the web.

TWO TYPES OF ADS

I will get into more details on Facebook advertising because it can get quite complex, but for now, these are the two main types of ads: lead and display. The display ad is the more common one that you will see, with its image or video leading you to a website or webinar, or maybe offering a download of a book. The potential customer gets something without committing quite yet (as they would have to do in the case of a lead ad). Eventually, all of those offerings may also get you the customers' email addresses, which is important because you will not make a sale to most of them right away. However, you will have their email to send more information in the hopes that they will buy in the future.

The last word on Facebook advertising for this chapter is that you can start with a small budget when experimenting. To begin, try just five or ten dollars per day for your budget, and see how things go. Even if you end up hiring someone to do most of the work, it is important to get your feet wet and understand the process.

CHAPTER 3
TAKEAWAYS

1. Try running a lead ad on Facebook with a small budget of five dollars per day.

2. Try running a display ad on Facebook, also with the same small budget.

3. Consider a webinar or small information download for your product or service.

NOTES

"In the early twentieth century, they tried selling soap as healthy. No one bought it. They tried selling it as sexy. Everyone bought it."
—Rose George, journalist

Chapter 4

SENDING OUT BULK EMAILS

The next step is how to write follow-up emails (and ad copy) to your potential customers once they sign up. You don't have to be a writer to do this; you just need to begin writing like you talk and follow some guidelines.

If you are running ads and obtaining email addresses (which was the goal of Chapter 3), then the next part of your funnel is sending out your emails. Your email list should be growing, and even if you have just fifty or one hundred email addresses, it's time to start sending them regular email blasts and coming up with a schedule and format for your writing. This is something you might be able to hire out as well, but initially, you should write them yourself. Even if you don't see yourself as a writer, you have to decide what the tone and the direction of these emails will be. They are part of your funnel, and you are the architect of this. So while you may hire people for different roles down the line, this is where you control the vision.

Most people new to sending out bulk emails get worried that they might send too many and turn off their customers. The first thing to know is that the best marketers out there are sending out at least an email per day. That's right: seven emails in seven days. You don't have to start off like that and may even end up doing less. Even so, I want to talk a bit about what to write, how often to send, and which services can help you with this. Also, if people unsubscribe, that's fine—ideal even—because you only want the people on your list who really want to hear from you!

CREATING AN EMAIL LIST

Your gathering of emails should be automated. This means that your ad should be collecting email addresses and sending them right to your email marketing service. This usually happens by a connecting service when people sign up for a webinar or free booklet. A useful tool called Zapier allows you to connect different platforms on the web. So, for example, if someone signs up for your free booklet or webinar, Zapier automatically adds them to your email list as well. There are services similar to Zapier, such as IFTTT (If This Then That), and more will surely keep coming out.

You don't have to be a writer to start an email campaign; you just need to begin writing like you talk and follow some guidelines.

EMAIL MARKETING SERVICES

Before you use Zapier, however, you need to find a service that sends out emails in bulk for you. There are many services out there, most of which are about the same amount of money to use, but costs will increase based on the number of your subscribers. That means five hundred subscribers might cost twenty dollars per month, whereas five thousand subscribers could cost much more. To mention a few services, I currently use AWeber but have also used iContact. MailChimp is the most popular because, instead of twenty dollars or less per month, it is initially free for up to two thousand subscribers. While that may sound attractive, they have no phone support, and believe me, you will need support at some point! AWeber has fantastic customer support, and I remain loyal to them. Unfortunately, Aweber doesn't have all the latest bells and whistles for marketers, but like many companies, they are playing catch-up. Drip, Infusionsoft, and ConvertKit are big ones that are a bit more expensive and offer a few more tools. In sum, if you are just starting out, I would suggest Aweber or something other than MailChimp because you want to be sure they have phone support.

HEADLINES AND SUBJECT LINES

Let's assume you have chosen an e-marketing platform and you have fifty email addresses, more or less. Now it's time to begin writing emails to build a relationship with your customers. I have sent out many types of emails, and I have hired experts to help me write the most effective emails. What I have learned is that, today, trust itself is what you must build. It is not simply about sending out emails telling people what you do; it is about building trust and positioning yourself as an expert in your field. I will give a few examples here of the content, but the headline or subject is also very important. The subject and how it is worded in an email is the reason your letter is read! You might write a terrific email, but if it is never opened, it doesn't matter. Therefore, the subject must be great! This also goes for headlines in your ads. What will they say to the potential reader?

A current rule of thumb is to have a headline or subject that sums up the entire article and points to the one thing left out, so you are compelled to read it. You have seen many examples of this, I am sure. There's this popular formula: "This One Weird Trick Will Cure Belly Fat." Now we know what the article will be about, and we want to know the missing piece—the "one weird trick." I'm not saying to use that specifically, but the formula is there. There are also others that you have seen, such as "Ten Foods You Should Never Eat for Breakfast" or "These 10 Images Are Impossible to Forget." Those lines could be the subjects for your emails or your ads, but of course, you will make up your own variations to reflect the content of your message.

TOP MARKETERS AND THEIR CONTENT

Let's look at a few top marketers and the emails they send. Seth Godin, a fifty-eight-year-old businessman, has written seventeen books on marketing and business and is one of the top business bloggers with over a million people on his email list. He writes emails every single day; they are often short and tend to sound like advice or ruminations on his daily experiences. As of this writing, recent titles of his emails include: "When Your Ideas Get Stolen" and "How to Give a Five Minute Presentation." He uses a company called FeedBlitz to send out emails. I often smile or laugh with him because he has a good sense of humor. He has established himself as an expert in his field through these tactics. When he decides to send out an email selling his new book, promoting a Kickstarter campaign, or even recommending a friend's product, his list now knows him well enough and is grateful enough for his emails that they look and are likely to buy.

Another great marketer is Ryan Holiday, thirty-one-year-old author of two books on marketing and two on philosophy. He also sends out an email every day for what he calls The Daily Stoic. It is an email series with messages that are always about Stoic philosophers and give quotes and short bits of writing on how to apply their philosophies to your daily life. It is inspirational and in the self-help field. Examples of his subject lines include "Why You Should Pretend Today Is the End" and "12 Questions That Will Change Your Life." Both of these stick closer to the headline formula I mentioned earlier—we know what his email is roughly about and we are compelled to read more.

Unlike Seth Godin, who usually isn't selling anything in every email, Ryan Holiday ends each email on philosophy with a suggestion to join his community (at ninety-nine dollars per year) so you can further discuss philosophy. That's all he is selling, plus his books from time to time.

The best way to research effective emails is to subscribe to people like this and others in your field and take very careful notice of which emails you actually open. Those are the ones you should emulate.

I send out emails four times per week, and on the weekend, I send a digest of all the emails that were sent during the week, as well as a new one. Like Ryan Holiday, whom I admire greatly, I give out tools for artists and offer my suite of courses (which are forty dollars per month) at the end of each email.

CHAPTER 4 TAKEAWAYS

1. Find an email marketing service and sign up. (I suggest you find one with phone support.)

2. Begin writing emails at least once per week on a specific day. Stick with this frequency and slowly increase it to more days per week. Write 200–500 words per email.

3. Include a pitch to buy your product or service at the end of each email, or on a regular basis, such as every other week.

NOTES

"I am interested in communicating with the world by selling to many people."
—Miuccia Prada

Chapter 5

GROWING YOUR FUNNEL

After your first sale, you will soon want to know how to scale or grow your funnel so that sales increase. This is when problems can occur because it is not as simple as just spending more on your ad that is working.

We are beginning to see the funnel in action. You place an ad on Facebook, you draw in email subscribers, and you write regular emails that build your reputation as an expert or "influencer." You build trust because you are giving out useful information. Sales are coming in, ideally on a predictable basis.

In my situation, I was doing this for almost a year, and things were going well. I was getting hundreds of subscribers a week, and I hired someone to run my ads for me. I was enjoying writing the emails. I was excited. I had a growing list of students. I began to make a profit and was able to invest more in the courses I was giving by hiring more teachers.

PROBLEMS

Then the problems began. I noticed that the return on investment was dropping. Previously when I advertised and sent people to a webinar, I could rely on a certain return on my investment. Suddenly, the profits began dropping off. I was making less, and the ads were costing more to run.

I tried not to panic and asked the person helping me with ads what he thought was wrong. He wasn't sure. He thought I should change images and try different ads. So I made video ads, I wrote new ads, and I waited to see what would happen. I kept watching the cost of my ads rise. I wondered if Facebook was somehow seeing the ads were successful and charging me more! In fact, what was happening involved a number of complexities.

Facebook was indeed changing its algorithm, the method by which it figures out where to place the ads based on your target audience. No one really knows how this works, but those who are advertising have to keep guessing, in effect, to figure it out.

I tried everything and still noticed that I was no longer getting the return on my money that I once did. In my haste, I fired the person doing the advertising because they couldn't figure it out, and I started from scratch. I hired someone to help me with emails, and I noticed sales improving a bit. He suggested that instead of just sending out good emails with helpful tips, I should make sure to end every email with a soft sell—just the option to purchase if readers wished.

FACEBOOK CALLS: ADVANCED TACTICS

Then Facebook called me on the phone! Maybe they knew something was up, but I doubt it. I think they saw I was spending a lot on Facebook, and they wanted to help me spend more.

When I talked to the Facebook expert on advertising and I told him my situation, he said I was having a problem "scaling." Scaling is a term for how businesses grow, how they scale up their outreach and revenues. I was indeed trying to "scale up" as you should be doing once you see some success with your ads. He told me he wasn't exactly sure what the problem was, and that it could be "ad fatigue," meaning my ad was getting old, or it could be how I am placing ads. Then he began to tell me things that were a bit beyond what I was doing, and it got complicated.

Instead of just sending out
good emails with helpful tips,
make sure to end every
email with a soft sell.

He explained how to make "Lookalike" lists. That means when you start to build a list of emails—let's say you have two hundred emails that came in through your ads—you can upload that list to the Facebook ad manager, and then Facebook will analyze that list and find you more people that fit the same profile. You see, Facebook has so much data on who people are (their interests, their gender, their age, their occupation). Based on info they have about the two hundred people who already signed up through your ad, their Lookalike list can generate a new audience and increase your outreach. That list, for me, began to help things grow again.

THE FORMULA FOR SCALING YOUR ADS

Then he said something else that revealed the inner workings of Facebook's algorithms. I told him I wanted to increase my spending on Facebook, but the more I increased spending, the less effective and more costly the ads were. He explained how to scale ads on Facebook. He said that if you begin to run an ad campaign where you are spending twenty dollars per day and you notice that it is working, the next thing you do is duplicate that campaign (their ad manager makes this easy). You increase your spending by no more than 10–15 percent. After seven to ten days, you will see if the ad campaign is still working well at that level; if it is, increase it by another 10–15 percent. This is the process of "scaling." If the increase is getting too expensive, keep using your original ad and try to target new audiences, perhaps in different states or countries in the world.

SPLIT TESTING

That may sound like a mouthful—and it is—which is why, when you get to this level, it is good to have someone help you. I recently talked to a Facebook representative again (they call me regularly now), and I asked more about finding the right audience. This time, I was told that you can do something called "split testing." This means you can test one of your ads on two different audiences and find out which audience is responding better. Again, this is a pretty advanced technique I couldn't do alone. However, when you do a split test, you can get an even more accurate sense of your audience. To make sure you have a large pool to work with, it is recommended that you use this technique when you have amassed at least three or four hundred email subscribers from your advertising campaign.

This is the email Facebook sent me when the split test was completed—

. .

Variable: Audience
Split: Even
Split Test Budget: $20
Schedule: Apr 18, 2018–Apr 22, 2018

WINNING AD SET
Using New Audience
Custom Audience:Lookalike (US, 1%)–10072016
Location: United States
Age:18–65+
Lookalike Oct List is the winning ad set with the lowest cost per result at $1.24. If you ran this test again, the chance of getting the same winner is greater than 95%.

. .

That is data that allows you to be more specific as to whom you are reaching to sell your product, art, or service. The split test is a great way to determine who you're having the most success with, so you can keep targeting people like them and continue to grow your funnel.

CHAPTER 5 TAKEAWAYS

1. Run your ads on Facebook until they decrease in effectiveness (costing too much and fewer sales coming in).

2. The next step is to try new ad types, and then scale according to the scaling formula: Every seven to ten days, duplicate your ad set and increase the budget by 10–15 percent. Keep doing this until it stops working and then stay there.

3. Change the ad copy and images regularly (at least once a month) to keep things fresh and working their best.

4. Learn how (or ask an expert) to conduct a "split test" to see who your very best audience is and refine your ad campaign to cater to people like them.

NOTES

"Many a man thinks he is buying pleasure, when he is really selling himself to it."
—Benjamin Franklin

Chapter 6

AUTOMATION OF SALES

"Automation" means your funnel operates by itself to bring in customers.

Once your funnel is working, you can automate the entire process. That does not mean that it will not need maintenance, but it does mean that the previous steps we have discussed can be automatically implemented without you doing it yourself.

You don't need to be doing all the advanced ideas in Chapter 5 to see results and move on to automating the entire process. In this book, we are talking about selling anything online—art, health products, services, or anything else. The process is always the same: if you want consistent sales, you want a funnel. The next step is to automate the entire process, so you can sit back and watch sales come in without going crazy!

AUTOMATION

The automation of the funnel covers the sequence of actions we've been discussing. Place ads on Facebook or Instagram. The ad gives away something, or people sign up to a list to learn more, or there is a free webinar. Now you have the potential customers' email and can send them repeated offers until they buy. The End. The next step is to make all that happen automatically, without you working every day or week on this process.

Automation means your funnel operates by itself to bring in customers.

Once you set up some ads and you see they are working, you begin sending emails to those people who sign up. From those emails, sales are then made consistently. You will begin by writing each email, but after a month or two, you should have a whole bunch of emails already written. I would suggest also having these emails on a blog so that anyone going to your blog will get great information. The next step is to have those emails automatically sent as soon as someone signs up.

Ideally your email campaign will consist of several messages at first, and as you keep writing, there will be dozens of emails ready to go. The next step is to use your email marketing program (like AWeber or another one) to send out those emails automatically. That means, after you have written a dozen or so, you can set them up to go out automatically at intervals. So let's say you send out emails three times a week: on Monday, Wednesday, and Friday. Now you can take all the emails you have written—even if it is just a dozen—and load them all into your email marketing program. The way you do that is to assign each email an interval of days when it goes out after a user signs up.

The first email sent out will be a type of welcome email. Something like your first email, thanking them for joining the list and telling them what they will receive.

The second email should be scheduled at an interval of 3 days later, the third email at an interval of 2 days later, the fourth email at 3 days later, and the series of intervals keeps repeating. Once the program has a series of emails loaded up, your funnel is ready to work automatically.

The ads keep going out → the potential customers sign up → the automated emails go out → until a sale is made! Then it repeats the process over and over, bringing in more customers and more sales.

Now you are at a fairly advanced point, as your sales funnel is working without you doing anything else to help it along.

Your emails or webinars are sending people to a page where they can buy something. . . . How will they buy it once they are on that page?

SALES PAGE

The one aspect we haven't talked about is your sales page. Your emails or webinars are sending people to a page where they can buy something, like your product, service, or art. How will they buy it once they are on that page? There are essentially two dominant methods used at the moment. One is PayPal, and the other is Stripe. There are other ways of processing payments, but these two are the most popular.

PayPal is the easiest way for people to pay if they already have a PayPal account because they don't have to enter their credit card info with every purchase; they just click a button—it's that simple. You can easily make a PayPal button for your website by using the "seller preferences" in your PayPal account. On the flip side, customers who *want* to use a credit card can still make a purchase by entering their info; PayPal still does the work of processing the payment for you, but the customer isn't obligated to start an account if they don't want to.

For credit-card-only transactions, Stripe seems to dominate at present, and it can process purchases for all major credit cards. Having both options is nice for your customers, but if you don't want to set up Stripe yet, PayPal is a good way to go at first because it provides customers with more options.

If you have a service to offer and a consult is needed first or the prices for your art are not listed, instead of a sales page, the process can end with a letter of inquiry (to set up a phone call or visit to your studio or shop).

You may be shipping an item, and if it is a small item like a tincture or similar body product, or perhaps a consistently sized work of art, be sure to add in shipping and handling costs. You can do this manually if it is always the same size, or you can use an automatic shipping calculator that can be added to most pages.

CHAPTER 6
TAKEAWAYS

1. Begin to automate your funnel.

2. Put your emails on a blog as you write them.

3. Set up a "campaign" in your e-marketing accounts so that your emails go out automatically, starting with a "welcome" email and following up at steady intervals.

4. Set up your sales page with a credit-card processor or PayPal. (If you are offering something that requires consultation, the final sale is actually a call or meeting. Make sure the relevant contact info will be provided to the customer.)

5. If you are shipping an item, calculate the shipping and handling costs or use an automatic shipping calculator to do it for you. Make that info available to the customer as part of the purchasing process.

NOTES

"Everyone lives by selling something."
—Robert Louis Stevenson

Chapter 7

AUTOMATION PROBLEMS AND SOLUTIONS

The next step is to know how to adjust the funnel when it becomes less effective. There is a system to this, too, because everyone that makes funnels will run into problems of continued growth and finding more and more customers.

As you have already seen, this process of making a funnel can get complicated, but the overall idea is still fairly straightforward. Now that you understand the architecture and some of the problems that can occur, let's talk about other issues that can come up when the automated funnel starts to be less effective and fewer sales are coming in.

This happened to me not long ago, and I had to look through all the parts of the funnel I have been describing to try to figure out what could be different. This is likely to happen to you as well. As I was struggling with this, I talked to the ad expert at Facebook again. I asked him what the top advertisers do on Facebook to keep their funnels working well. He told me the best advertisers are changing their "creative" all the time. That means they change the images they use for ads, the copy, and the initial giveaways, like a booklet or an information packet.

THE GIVEAWAY

I went back to the original display ad and looked more closely at what I was offering people when they signed up for a free webinar. This is the entry point to the funnel that attracts people to what you are doing.

As I said earlier, if you are selling a health product, you may want to give away a useful set of tips for being healthy, or if you offer a service like a real estate broker, you might want to include a set of tips about the common mistakes home buyers make. If you are an artist and looking to sell art to collectors, you might want to give away a guide on "how to collect art."

Running with this example of the artist looking to build a mailing list of collectors who might want to buy your art—if the funnel is no longer working, you can start at the beginning and change what you are offering in the ad.

Perhaps instead of giving away a series of tips on "how to collect art," it could be something like "ten things first time art collectors get wrong." That may attract more attention because it implies that the reader may not be aware of something they are doing wrong when collecting art. (Examples of what they might be doing wrong could be that they are not researching the artist thoroughly before purchasing or neglecting to ask about past sales to make sure they are getting a good price.)

That is the first place in your struggling funnel to look for ways to make improvements, and it's what I did. I made several new types of documents to give away, and then when I ran all those ads, I watched which one was doing the best and cancelled the rest.

Experiment and be creative and see what your audience reacts to.

EMAIL CONTENT

You can also look at your emails that are sent out and notice which ones get replies and which ones are the most popular. In all email marketing services, you can see how many people opened your emails and how many clicked on a link in your email. Use that data to figure out which emails were the most popular and analyze why that was the case. Sometimes it has to do with the subject line, and other times it may be the engaging content. Experiment by changing the content of your emails and notice if new ones are more popular. Try to emulate the ones that readers like most.

The way you write an email is how readers begin to trust you. When in doubt, write the way you talk. If you are struggling too much, you can get the help of an editor, but the writing still has to be yours because it is your voice that the readers will trust, not just the information.

Consider changing the content of the email altogether. Experiment and be creative and see what your audience reacts to. One way to get ideas is to look at the emails you are getting from people like Seth Godin or Ryan Holiday. Notice which emails of theirs you like and which ones you do not like. Subscribe to other bloggers who send out emails often, and in this way, you can learn a tremendous amount from the best out there just by noticing which emails you are actually reading and engaging with and which ones you don't read at all.

YOUR CHECKOUT PAGE

The other area of your funnel to tweak and revise is the last part of it: the checkout page. That is the page you have paid dearly for your potential customers to reach.

One thing you can do to improve this page is to add testimonials from your customers saying how much they like your art, your service, or your product.

Ask friends to look at the checkout page to see if they find it attractive and clear, and ask them if something can be improved. They don't need to be experts in web commerce to give advice—we have all bought things on the internet, and we all know what makes it easy or not to hit the "buy" button!

CHAPTER 7 TAKEAWAYS

If your funnel is becoming less effective . . .

1. Look at the first entry point (your ad) and change the incentive or give-away item.

2. Review your email content and look at the messages that performed the best and got the most opens and clicks.

3. Review your checkout page, add testimonials, and ask a few friends to look at it to make sure it is clear and easy to use.

NOTES

"Selling beauty is something I can understand, even selling false beauty seems perfectly natural; it's a sign of progress."
—Émile Zola

Chapter 8

BUILDING A
REMARKETING CAMPAIGN

You are now a good way into a very sophisticated technique with many moving parts. The next step is something called "remarketing," which is really the most powerful tool on the web for e-commerce. Remarketing means that, when a potential customer "likes" your ad or gets as far as your checkout page but doesn't buy, you still have a way to reach them. This is also referred to as "retargeting" because you are specifically targeting and marketing to a customer for the second time. I will use the terms "remarketing" and "retargeting" in much of this chapter because marketers use them often and you should be familiar with them.

I am sure you have already experienced the remarketing effect yourself. Have you ever looked at something on eBay—or anywhere else online—and noticed that an ad for that one thing you considered but didn't buy keeps popping up as a display ad everywhere you go on the web? That's remarketing, and you can use this tool as well.

RETARGETING TOOLS

Google and Facebook are both useful for their remarketing tools. On Facebook, for example, when people like your ad but don't go further into your funnel, you can make special ads for "retargeting" them. The ads that you run should be different than the others and should reference what the audience knows about them already. If it is a health product you are selling, you might ask in a retargeting ad, "Are you still interested in knowing how to make your skin softer?" Or if you are offering a service like a real estate broker, you could ask, "Are you still looking for a home?" Or if you are an artist running ads targeting collectors: "Are you still buying art for your collection?" Then if they click on your ad, it goes to the same funnel that the original ad went to, and that way you get another chance of capturing them on your mailing list and sending them emails.

Facebook allows you to retarget on their site using data from the ads you ran, which is, essentially, a list of who clicked or liked an ad but didn't go further. However, the retargeting stays within Facebook. Google does the same thing, but the ads will be run all over the web wherever the potential customer goes. That is how most retargeting is done. Bing and other search engines can retarget as well, but Google is dominating the web retargeting field at the moment.

To set this up, there are different tools for each platform. For Facebook, you have to add a feature called a "pixel" on different pages of your website or your checkout page. On Google, you would use Google AdWords. Essentially, each of these features is a "cookie," which is a digital marker of your potential customers' online behavior as they go from site to site. Using cookies to track activity is one of the most effective ways to reach customers who have shown interest but didn't buy. Customers like that are considered "strong leads." At the very least, they belong on your mailing list.

**When hiring people,
be very, very clear
about what you want.**

HIRING PEOPLE TO HELP YOU

To set up remarketing tools, you can search Facebook or Google and follow along with their instructions which include inserting bits of code onto various pages. Or, if you find that intimidating, you can hire someone to set it up for you. The way I hire people to help with tasks like this is through a site called Upwork. On this site, you can search for freelance tech support and other types of assistance. It's important to be careful about whom you hire. A rule of thumb on that site is to look at their ratings from other people they have worked for. Have they logged more than five hundred hours? That is a minimum for me to hire someone. How good are their ratings?

The important thing to remember when hiring people this way is to be very, very clear about what you want. You are setting up the ads, and you know your audience. They are helping you do the complex advertising and retargeting, but only you know the results you are looking for and the architecture of your funnel. Also, don't pay people until the job is done, or if it is an ongoing gig, such as managing ads, pay them after a specific goal is reached, such as a week of running ads and targeting new audiences.

On Upwork, you can hire people from anywhere in the world, and they can help you with almost all of the tasks I have mentioned so far. You can negotiate with them as well, but when you initially post a job, name a price. (And don't worry if it is too low; you will get feedback soon enough!) When you find a freelancer you want to hire, the two of you will sign a contract outlining the tasks to be done. When it comes time for payment, Upwork will take care of the transaction and take a percentage. This ensures, to the extent that such a process can, that everything works out smoothly.

Trust is a huge factor here, as you don't want someone who is inexperienced to have access to your business. The best way to avoid problems is to work with a very experienced person—one who has logged a minimum of five hundred hours but preferably closer to one thousand hours on Upwork and also has excellent reviews.

CHAPTER 8 TAKEAWAYS

1. Retargeting is essential to a strong funnel. Use Facebook and Google for this.

2. Hire an expert to set up your retargeting campaign, so you can track customers with cookies.

3. Look at sites like Upwork to hire these freelancers and be sure their profile shows at least five hundred hours of work completed and lots of positive reviews.

4. When you post your job, name a price and negotiate if necessary, but only pay when the job is done.

NOTES

"Selling is essentially a transfer of feelings."
—Zig Ziglar

SELLING WITHOUT A FUNNEL

The process I have outlined so far may seem daunting, but it is the only way to build truly consistent sales. However, if you just want to get your feet wet in selling anything online, you can also use eBay or Instagram or platforms that allow you to put your creative designs on products like t-shirts and mugs. Here are some of the sites you already should be familiar with, and the process for all of them is very similar, with the exception of Instagram.

EBAY

On eBay, you can sell your product or art, but not a service. If you have a small product, like candles, herbal tinctures, or something else, it is easy to set up a store and begin listing all your products. The more you have up, the better. When you start selling, ask customers for testimonials and pictures, and list them on your site because that helps drive sales.

You can also sell art on eBay, and many people do. The best way to see what successful eBay stores look like is to search for products that are similar to yours. The ones that are very successful are using it all the time and making sure things get shipped out right away and the customer is satisfied. For artists, posting a new work on eBay every day is ideal—or at least three times a week—and if something doesn't sell or doesn't meet a reserve you set, keep relisting it until it does.

There are many types of things that sell on eBay and also things that don't sell so well. In general, high-priced items don't do very well. Art for over six hundred dollars, for example, or a house, is something that most customers will feel they want to see before making a decision.

Fees are taken out of sales as payment for using the platform.

ETSY

Etsy is similar to eBay, except that this site is largely for arts and crafts. Like eBay, keeping active and satisfying your customers is essential. There is a rating system similar to eBay's. Shipping on time is highly valued. Fees are taken out of sales as payment for using the platform.

AMAZON

Selling on Amazon can be done in two ways: either they take $0.99 per item sold, or you can pay a flat monthly fee of $39.99. The latter method is ideal if you're selling well over forty products each month. The upside is that they are a huge marketplace. Because millions of customers buy there, it is possible your product can be discovered. However, Amazon is about promoting itself only, so your brand and your visibility is not their main concern. However, it is worth trying if you are so inclined, but to really make sales consistent, you will still need to find a way to stand out from the crowd. This is where your email campaign—or simply a great product—can help the process.

TWITTER

While Twitter is not considered a sales platform for most people, you can run ads on Twitter and create a funnel-type situation. Because Twitter does not have the customer data that Facebook has, it is much harder to dial in your audience. But it can still be used to promote your product, service, or art, even without using ads. By posting consistently and engaging other users with comments, you can begin putting your work out there.

INSTAGRAM

Instagram is a platform where people can showcase their product, service, or art, and easily direct customers to their website or a third-party service to purchase it. It is also owned by Facebook, so if you advertise there, you will have similar tools. However, many people sell on Instagram without advertising at all.

I will give an example of an artist selling art on Instagram, but the same example could be used for other products as well as services.

Dan Levin is an artist who has done well on Instagram selling his art, and this is his story.

His first art show was a college group exhibition in 1984. He's been selling his art consistently ever since. Social media has made a big difference and increased his sales over the last few years. As much as he still likes a curator or a gallery reaching out to him for inclusion in a show, he says, "There is definitely a satisfaction in representing myself and getting images of my work in front of thousands of potential art collectors around the world."

He started with Facebook. Most of the work Dan showed on his "timeline" was assemblage art or sculpture. He started with a personal page, then made a business page. He never used hashtags and focused more on communicating with anyone who left a positive comment about a particular piece of art. At that point, he would message them and say that the piece was available. Occasionally, he would ask them if they wanted to make an offer. He started shipping pieces all around the world, to places like Great Britain, Germany, France, Sweden, Australia, and New Zealand, as well as throughout the US.

If you just want to get your feet wet in selling anything online, you can use eBay, Etsy, Instagram, or other platforms.

Once he created a profile on Instagram, sales increased dramatically for two reasons. He started using hashtags, which had a big impact on how many people saw his work after doing their own tag searches. He likes using as many tags as possible to cast a very large net. The other reason sales increased was because he began to zero in on a particular series of work that had a large following on Instagram. This was playing-card art. His biggest seller on Instagram happens to be decks of cards that he cuts through carefully and intricately to the ace of hearts. The cards are then glued together and ready to hang. He calls them "Lonely Hearts altered playing card decks." As of 2018, he has cut approximately four hundred decks and sold many of those on Instagram. The hashtags—such as #art #playingcards #playingcardart #paperart #danlevinslonelyhearts—have really helped him. He also follows people who design playing cards, and they often ship him dozens of decks at no charge, with and without commissions, to cut their playing cards into designs.

He says, "The followers have to be folks who are genuinely interested in art or playing cards. If they aren't, it's just dead weight."

CHAPTER 9
TAKEAWAYS

1. If you're not ready for a funnel, get your feet with selling directly. Sales may not be consistent, but it's a start. You can build your funnel later.

2. eBay and Etsy are similar in that you can offer what you have without paying a membership fee. (They do take a fee as a percentage of what is sold.)

3. Amazon is a giant with a large audience. They'll take $0.99 per item sold, or you can pay a flat monthly fee of $39.99.

4. Instagram is a powerful place for some products; using hashtags allows you to be exposed to a specific audience.

NOTES

"I can say with full sincerity that I am happy. I'm happy because I'm doing what I love and I'm not selling out."
—Columbus Short

Chapter 10

RAISING CAPITAL

You may find that you also might need to raise capital for growing your sales. If your particular business needs more financing and a cash infusion to grow, consider what you need to take the next leap in your business. Create an outline to help you focus on what's most important and time sensitive.

No matter what you want to sell online, in most cases, you need some start-up capital to do it. When I began selling online courses, I didn't have very much capital, just a small savings account, but my product was largely virtual. I was offering an online service. As my business grew, I could put profits back into the funnel to make it grow more. However, for others selling art, products, or services that require offline support as well, you may need money to get your funnel started, to hire people and build your website, and to pay for advertising and growing your funnel.

START-UP CAPITAL

There are many ways to get funding, and one is to have some type of one-time fundraiser, which can be as creative as you like. In my book *Fund Your Dreams Like a Creative Genius*,™ I discuss what the founders of the now-huge company called Airbnb did to raise capital for their business. They made and sold cereal boxes during the 2008 Democratic National Convention. They made Obama O's and Cap'n McCain's. Their cereal boxes had illustrations of each candidate and were filled with real cereal. Since the printer sent the boxes flat, they had to assemble and hot glue each one. They made five hundred of each and sold off all of the Obama O's and almost half of the Cap'n McCain's. In the end, they made $30,000 on the themed cereal.

There are no limits to how creative you can be in raising capital, and *Fund Your Dreams Like a Creative Genius*™ suggests many ideas, including going to venture capitalists and angel investors. If you feel you need an infusion of cash to get going, then I suggest you buy that book which is as concise and inexpensive as this one.

EXPERIMENT AND ASK YOUR AUDIENCE

Most likely, you will not need an infusion of cash to start a funnel and sell things online. You can begin testing the waters by just posting your service, product, or art on your personal Facebook page before you even get a Facebook business page. Be sure to make it clear that the product, service, or art is for sale and give a price. Also, give people a way to buy it, such as PayPal, or tell them to message you if they are interested (but ideally give them a way to pay for it; this makes things far easier and avoids back and forth on payment details). If people just "like" it but don't buy it, then you can also ask your friends on Facebook what they think of your work or service and why they would or would not buy it. That is a soft way of testing the market and getting feedback.

Getting feedback is a good way to start any adventure selling online, so don't hesitate to read this book and, right away, start offering what you have for sale on Facebook, Twitter, Instagram, or any other online platform. You aren't paying for ads, so just put it out there and be bold. If you don't get enough responses or a sale, then ask for feedback. It's simple: just ask friends for help—ask what they thought of your ad or your item for sale and why they would or wouldn't buy it. However, if you do get any sales at all in that trial, then you are on the right track—keep it up and make a funnel!

CHAPTER 10 TAKEAWAYS

1. Decide if you really need start-up cash to begin selling online.

2. Consider fundraising strategies if you need a cash infusion. My book *Fund Your Dreams Like a Creative Genius™* is filled with ideas for fundraising if needed.

3. Try testing your product, service, or art without a funnel or ads. Just post it on a social media platform of your choice, be sure you have a way for people to buy it, and ask for feedback.

NOTES

AFTERWORD: YOUR HEALTH

Your physical and mental health is the top priority.

Above all else—and I wish I didn't have to say this—you must take care of yourself in terms of diet, fitness, and mental health. Managing a new life of success has continual challenges emotionally and strategically. Essentially, you want to remain healthy and happy, not overworked and stressed.

Although this is a book about sales, mental and physical health will have an impact on being an entrepreneur. In any adventure like this, there will be uncertainty and stress. That is something you can count on. Rather than alleviating it with overeating, smoking, or other bad habits, choosing a consciously healthy path will not only relieve stress, but it will also give you more energy to tackle the difficulties and challenges that will surely arise.

Everyone has a different set of tools that work for them to relieve stress and pursue health, but I will suggest the ones I find most helpful.

Every day, I go for a walk of about two miles, first thing in the morning. This is a great reliever of stress, no matter where you live. In a city, in the woods, or somewhere in between, there is an undeniable simplicity and health benefit to a daily walk. Sometimes I run a bit, but walking is enough. I swear by this routine, and it has served me well.

When I am done with a walk, I do a short yoga video (ten minutes long). This is no yoga class, but it is good to stretch and also a nice way to relax.

After yoga, I use an app on my phone called Breethe which offers a variety of guided and unguided meditations. I select a brief ten-minute session.

Those three activities set up my day, and I get up extra early, depending on my schedule, to have the time to do them. This is not a book on stress-relief techniques, but entrepreneurship— such as building a funnel and keeping track of all your activities online–can be stressful. Finding a way to relieve the stress is essential to your success, whatever you are selling.

Those are the things that work for me, but you might need a different combination. Whatever it is, be sure to take good care of yourself in advance of and during all this work. Know that, as you start getting more successful, there will also be setbacks and then more success. It is the pattern of almost all businesses. Finding a way to relieve stress is one of the most important elements to not only the success of your selling online, but your well-being in general.

I wish you great luck and all good
things in your creative venture.

If you don't try, you'll never know, right?

Be bold, be beautiful, be the Creative
Genius that you know you are!

For more support, watch the videos on
museumofnonvisibleart.com/creativegenius/

SUGGESTED READING

Here are books that will help
you think more about the ideas
in this book. Some are directly
related to sales and marketing,
and others are favorite books
of mine that will feed your mind
and generate more ideas.

Água Viva—Clarice Lispector

The Art of the Pitch: Persuasion and Presentation Skills That Win Business—Peter Coughter

Ask Without Fear! A Simple Guide to Connecting Donors with What Matters to Them Most—Marc A. Pitman

Autobiography of a Yogi—Paramahansa Yogananda

Between the World and Me—Ta-Nehisi Coates

A Brief History of Time—Stephen Hawking

Complete Poems, 1904–1962—e. e. cummings

Cradle to Cradle: Remaking the Way We Make Things—Michael Braungart and William McDonough

The Creative Habit: Learn It and Use It for Life—Twyla Tharp

The Daily Stoic: 366 Meditations on Wisdom, Perseverance, and the Art of Living—Ryan Holiday

Fund Your Dreams Like a Creative Genius™—Brainard Carey

Growth Hacker Marketing: A Primer on the Future of PR, Marketing, and Advertising—Ryan Holiday

How to Sell Anything to Anybody—Joe Girard

Leonardo da Vinci—Walter Isaacson

Man's Search for Meaning—Viktor E. Frankl

Meditations—Marcus Aurelius

The Obstacle Is the Way: The Timeless Art of Turning Trials into Triumph—Ryan Holiday

On the Shortness of Life: Life Is Long If You Know How to Use It—Seneca

A People's History of the United States: 1492 to Present—Howard Zinn

Regenesis: How Synthetic Biology Will Reinvent Nature and Ourselves—George Church and Ed Regis

The Revolt of the Masses—José Ortega y Gasset

Sapiens: A Brief History of Humankind—Yuval Noah Harari

Self-Reliance and Other Essays—Ralph Waldo Emerson

Stoic Spiritual Exercises—Elen Buzaré

Trust Me, I'm Lying: Confessions of a Media Manipulator—Ryan Holiday

The Undiscovered Self: The Dilemma of the Individual in Modern Society—C. G. Jung

You Are a Badass: How to Stop Doubting Your Greatness and Start Living an Awesome Life—Jen Sincero

INDEX

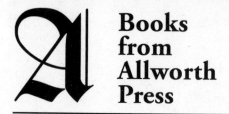

Books from Allworth Press

The Art of Digital Branding
by Ian Cocoran (6 × 9, 272 pages, paperback, $19.95)

The Art World Demystified
by Brainard Carey (6 × 9, 308 pages, paperback, $19.99)

Brand Thinking and Other Noble Pursuits
by Debbie Millman with foreword by Rob Walker (6 × 9, 336 pages, paperback, $19.95)

Branding for Bloggers
by Zach Heller with the New York Institute of Career Development (5½ × 8¼, 112 pages, paperback, $16.95)

Feng Shui and Money (Second Edition)
by Eric Shaffert (6 × 9, 256 pages, paperback, $19.99)

From Idea to Exit (Revised Edition)
by Jeffrey Weber (6 × 9, 272 pages, paperback, $19.95)

Fund Your Dreams Like a Creative Genius™
by Brainard Carey (6⅛ × 6⅛, 160 pages, paperback, $12.99)

How to Survive and Prosper as an Artist (Seventh Edition)
by Caroll Michels (6 × 9, 368 pages, paperback, $24.99)

Making It in the Art World
by Brainard Carey (6 × 9, 256 pages, paperback, $19.95)

Millennial Rules
by T. Scott Gross (6 × 9, 176 pages, paperback, $16.95)

The Money Mentor
by Tad Crawford (6 × 9, 272 pages, paperback, $24.95)

The Secret Life of Money
by Tad Crawford (5½ × 8½, 304 pages, paperback, $19.95)

Selling Art without Galleries (Second Edition)
by Daniel Grant (6 × 9, 256 pages, paperback, $19.99)

Starting Your Career as a Professional Blogger
by Jacqueline Bodnar (6 × 9, 192 pages, paperback, $19.95)

Website Branding for Small Businesses
by Nathalie Nahai (6 × 9, 288 pages, paperback, $19.95)

To see our complete catalog or to order online, please visit *www.allworth.com*.